Souvenir of the Canadian Rockies

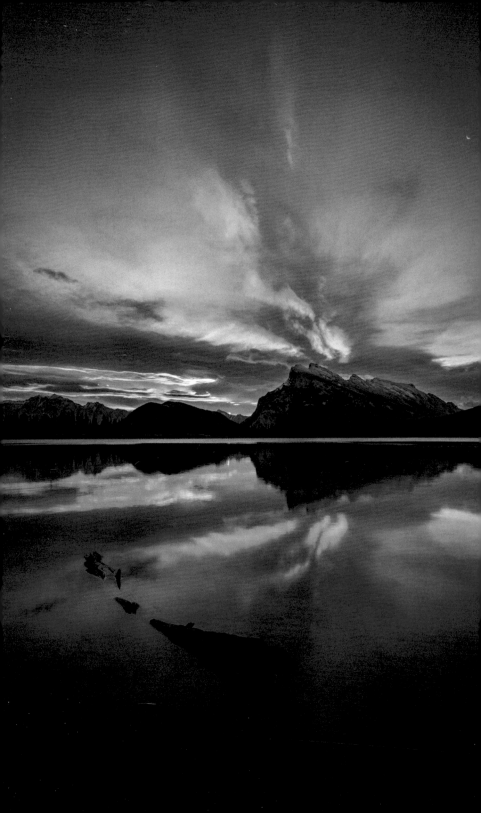

SOUVENIR
of the
CANADIAN ROCKIES

RMB

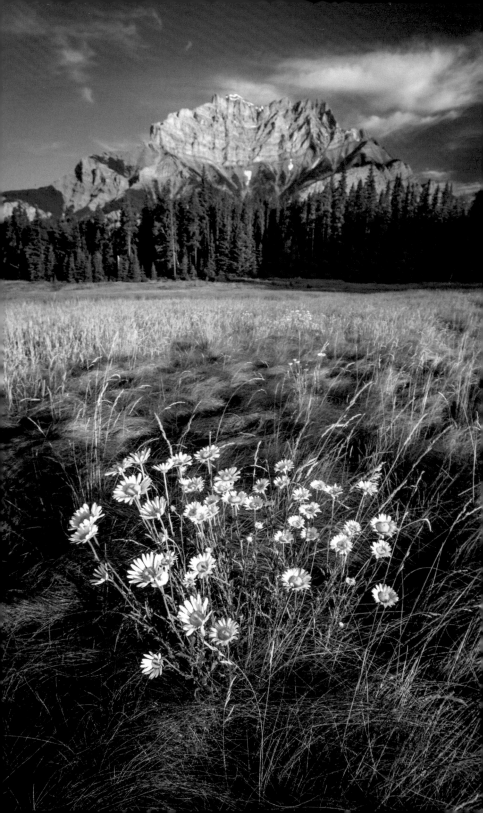

INTRODUCTION

Anyone who visits the Canadian Rockies knows that the mountains possess an incomparable allure and grandeur that sets them apart on the global stage. This spectacular mountain range is home to a number of national and provincial parks, many of which are included in a UNESCO *World Heritage Site. It is a tribute worthy of a region with such astounding natural features and biological diversity.*

The most iconic scenes of the Canadian Rockies are both rugged and beautiful, from the glacier-clad peaks of Banff to the cascading waterfalls of Yoho, the majestic lakes of Jasper to the towering summit of Mt. Robson. Just as

Cascade Mountain was named in 1858 by James Hector as a translation of its Stoney name, Minihapa, or "mountain where the water falls," which references the prominent waterfall on its southeastern face.

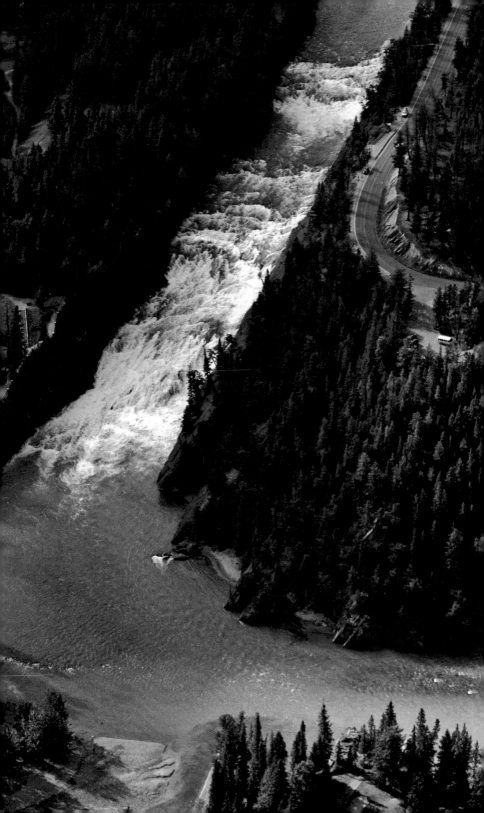

dramatic are the seasonal changes, with golden-hued larches illuminating the forests in autumn and a blanket snow quieting the landscape in winter. It is little wonder why the region has been a sought-after destination for visitors for over 130 years – a tradition that is showcased by the area's impressive hotels, historic mountain lodges, cultural attractions and museums.

Souvenir of the Canadian Rockies comprises a selection of images that highlight the region's most famous scenery and significant landmarks. May it be a cherished memento of the magnificent and unparalleled beauty of this remarkable corner of Western Canada.

This aerial photo of Bow Falls offers a unique perspective of the surging waterfall, which cascades towards the confluence of the Bow and Spray rivers.

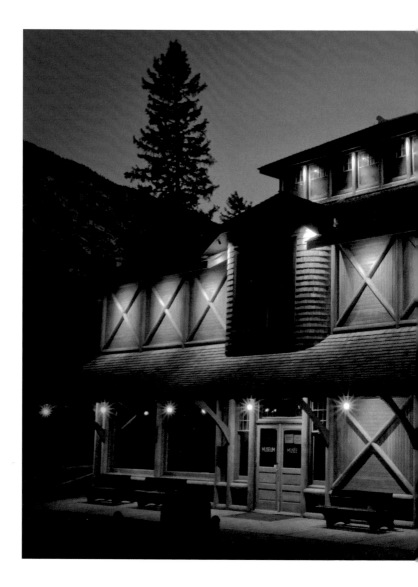

A National Historic Site, the Banff Park Museum is housed in a log cabin constructed in 1903. It is the oldest museum of natural history in Western Canada.

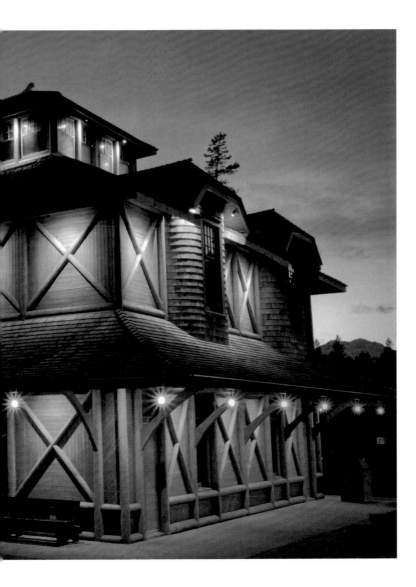

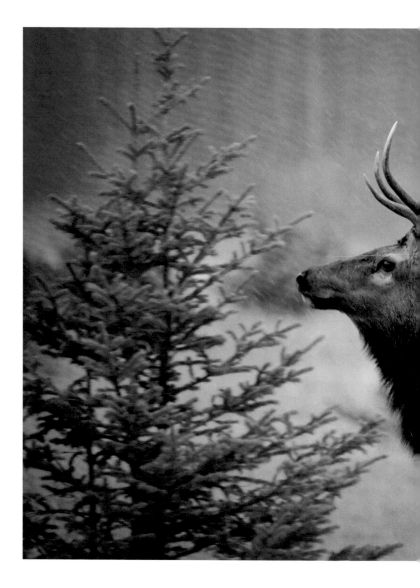

Elk, or wapiti, are large ungulates native to the Canadian Rockies.
Each spring, the males grow antlers – some nearly four feet long –
which are shed in winter.

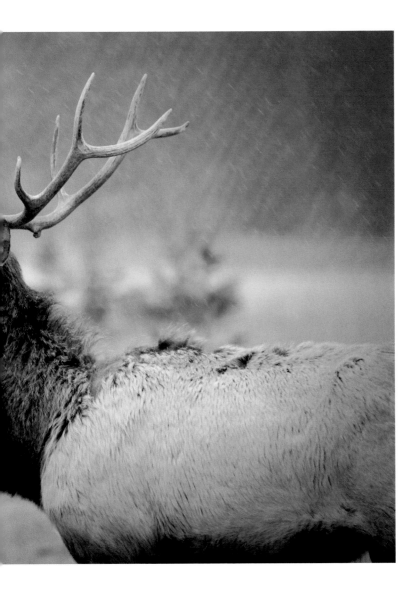

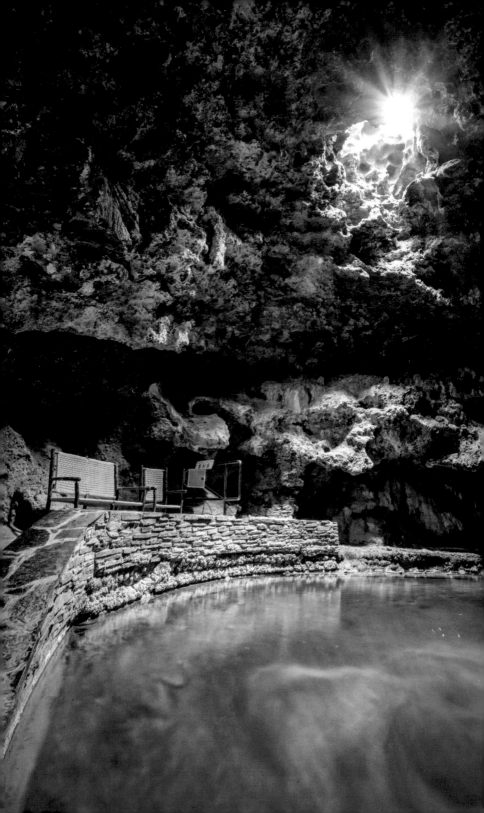

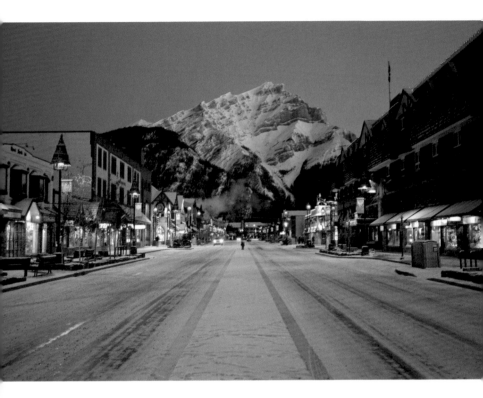

ABOVE *When the Banff townsite was laid out in 1886, superintendent George Stewart oriented the town's main street so that it offered a perfect view of Cascade Mountain.*

OPPOSITE *Walk through the tunnel that leads to the cave at the Cave and Basin National Historic Site (pictured here) and you get a waft of the sulphuric smell that emanates from the thermal waters.*

A rainbow illuminates the sky over Mt. Inglismaldie, Banff National Park.

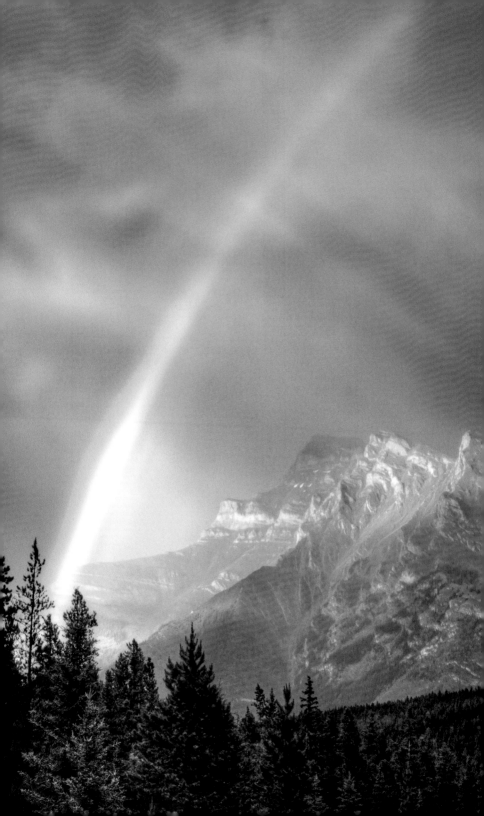

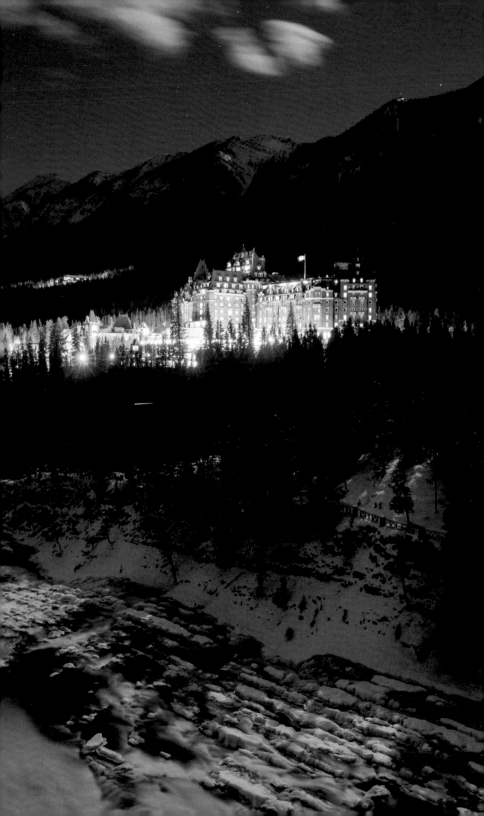

The Fairmont Banff Springs Hotel was originally constructed in 1888 as part of CPR vice-president William Cornelius Van Horne's grand plan to build luxurious railway hotels throughout the Canadian Rockies.

Hoodoos, like these in Banff National Park, are geological formations composed of relatively soft rock covered by harder, less easily eroded rock. Over time, the elements have worn away the surrounding rock, leaving behind these oddly shaped columns.

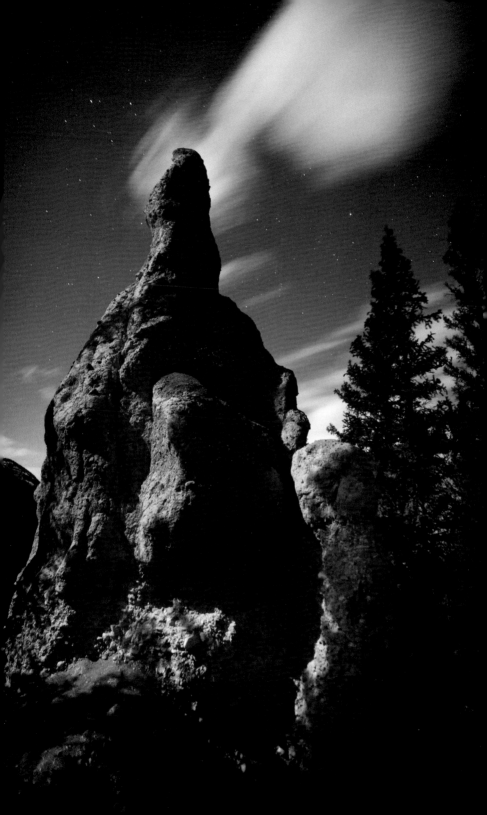

Lake Minnewanka (Stoney for "water of the spirits") is the largest lake in Banff National Park. The Lake Minnewanka Boat Cruise (pictured here at centre) provides views of the surrounding peaks.

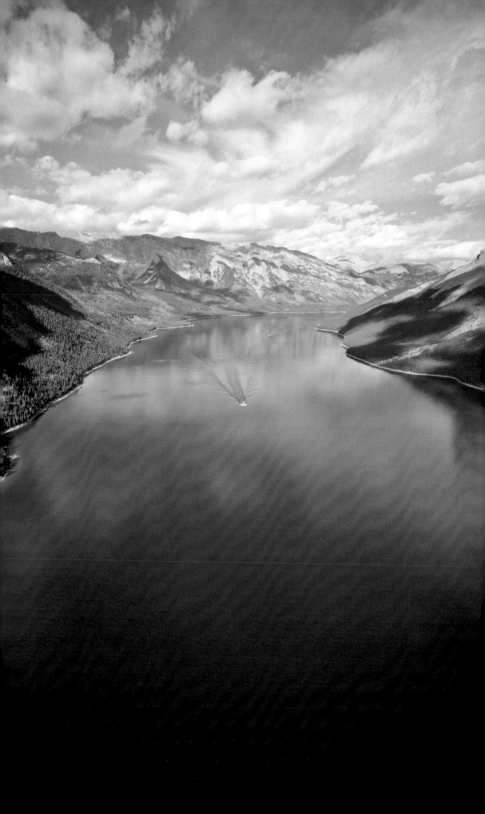

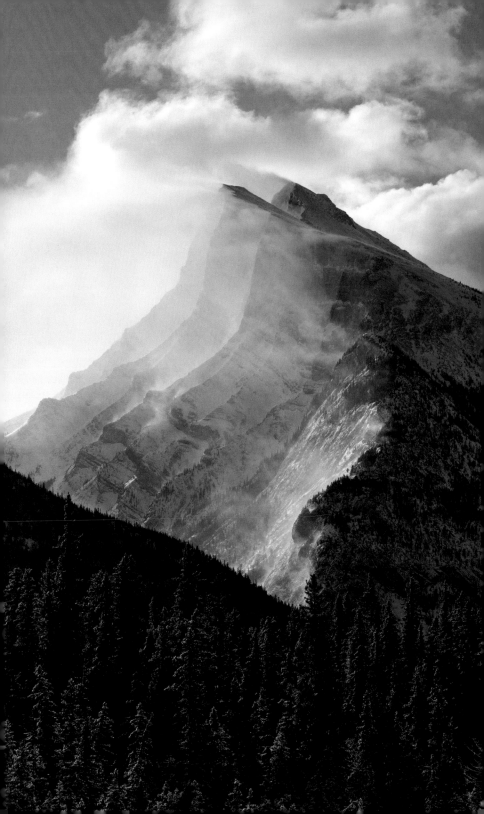

Snow drifts
from the wind-
scoured, serrated
peaks of the
2948-metre-high
Mt. Rundle, Banff
National Park.

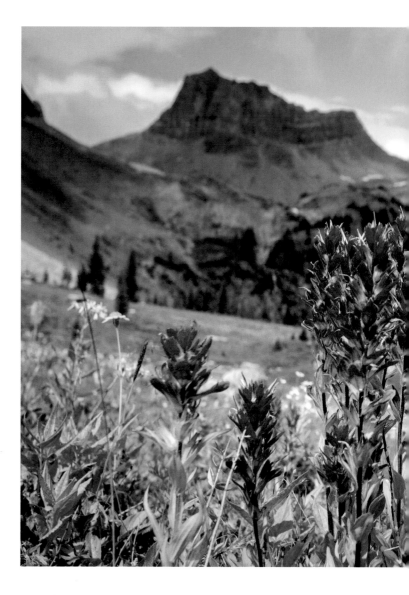

The Indian paintbrush comes in a variety of colours, from blood red to pink or orange and, more rarely, yellow or white.

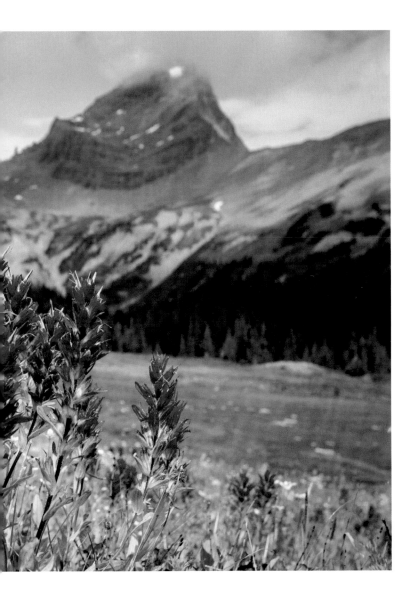

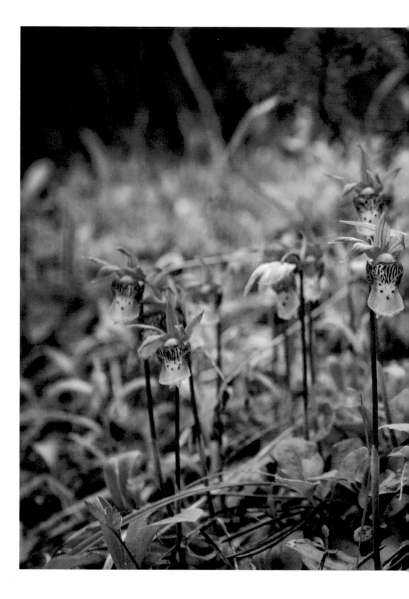

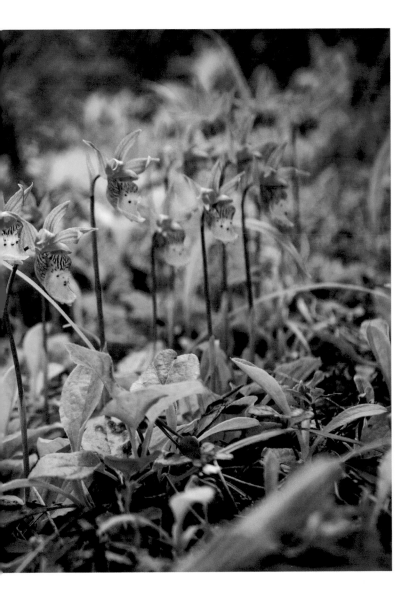

*One of the most beautiful wildflowers found in the Canadian
Rockies, the calypso orchid grows in shaded forest areas.*

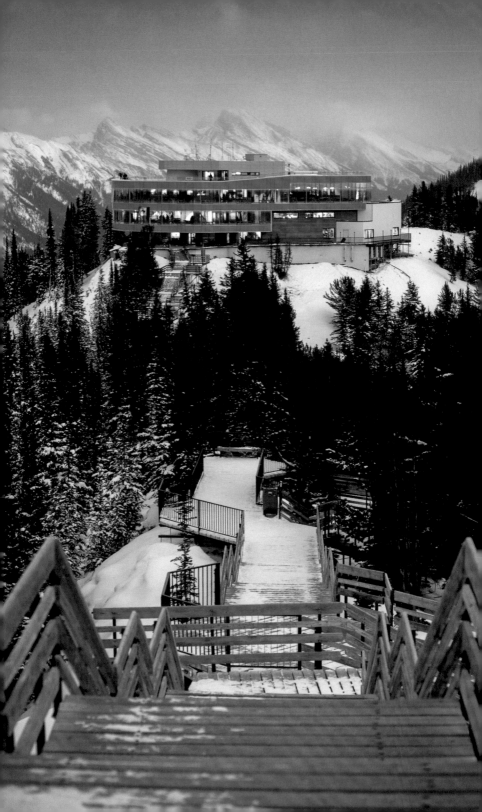

The Sulphur Mountain Gondola climbs 700 metres up the side of its namesake peak to an upper terminal (pictured here), a state-of-the-art venue featuring interpretive displays, a gift shop and restaurants with the best views in the Banff region.

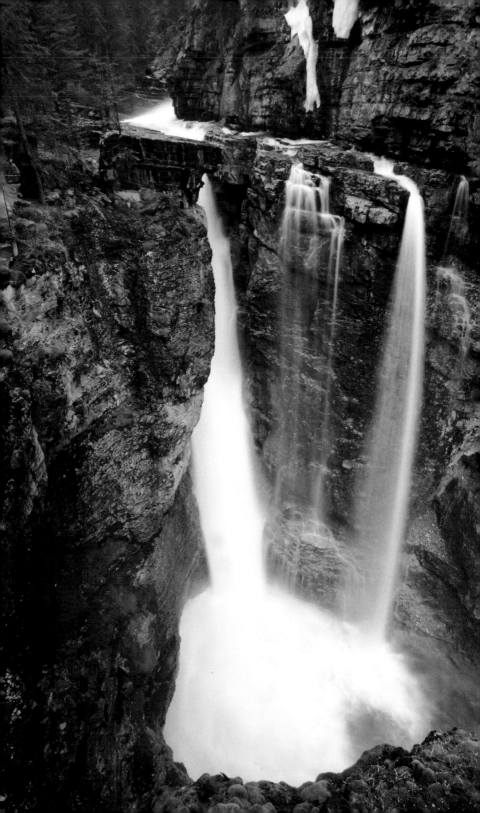

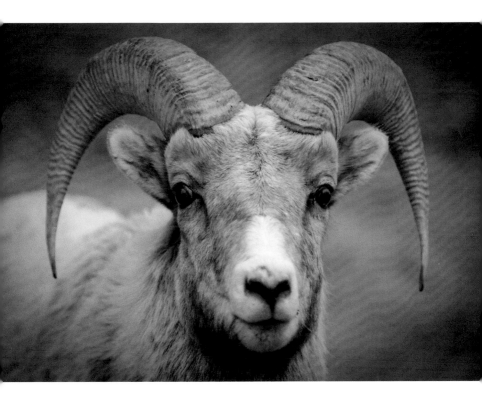

ABOVE *Easily recognized for their curved horns (in males), the Rocky Mountain bighorn sheep are wonderful to look at but a force to be reckoned with. Large males can weigh up to 500 pounds!*

OPPOSITE *At Johnston Canyon, you can hike interpretive walkways – some built right into the canyon walls – to the base of two waterfalls, the Upper and Lower Falls, pictured here.*

Named for its shape, 2766-metre-high Castle Mountain was formed as weak layers of shale eroded over the course of centuries, leaving behind more resistant limestone towers.

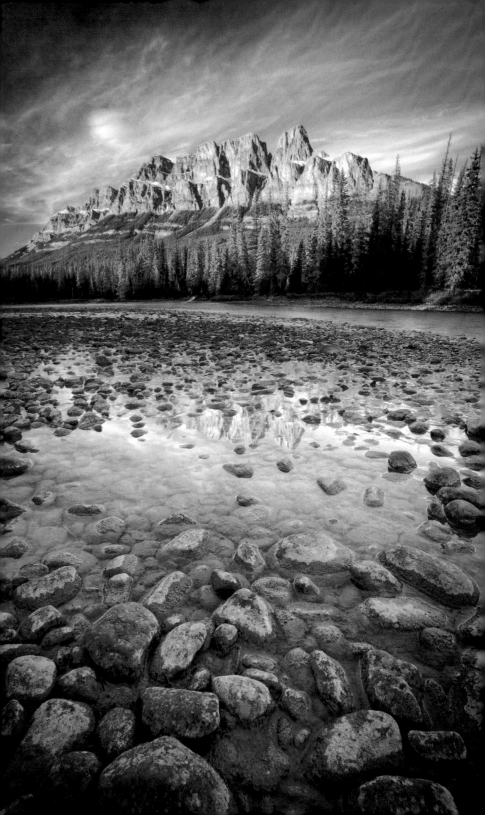

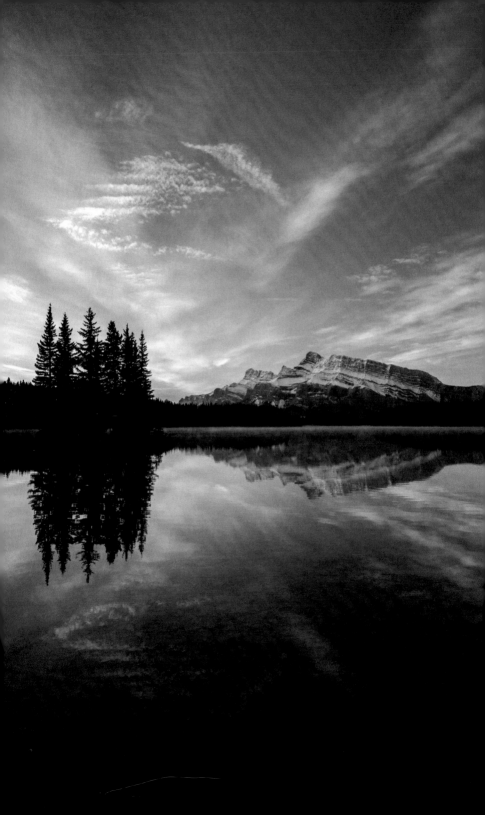

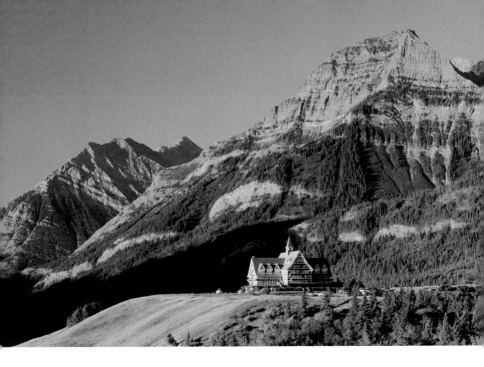

ABOVE *The Prince of Wales Hotel
in Waterton Lakes National Park has
an illustrious placement on a hillside
overlooking Upper Waterton Lake. It was
designated a National Historic Site in 1995.*

OPPOSITE *Two Jack Lake is named
after two men who lived and worked in
the Banff area in the early 20th century:
Jack Standly, the boat operator at Lake
Minnewanka, and Jack Watters, who
worked in the mines at nearby Bankhead.*

Red Rock Canyon is one of the most striking
features in Waterton Lakes National Park.
Its colour comes from iron-rich shales that,
when oxidized, turn a bright shade of red.

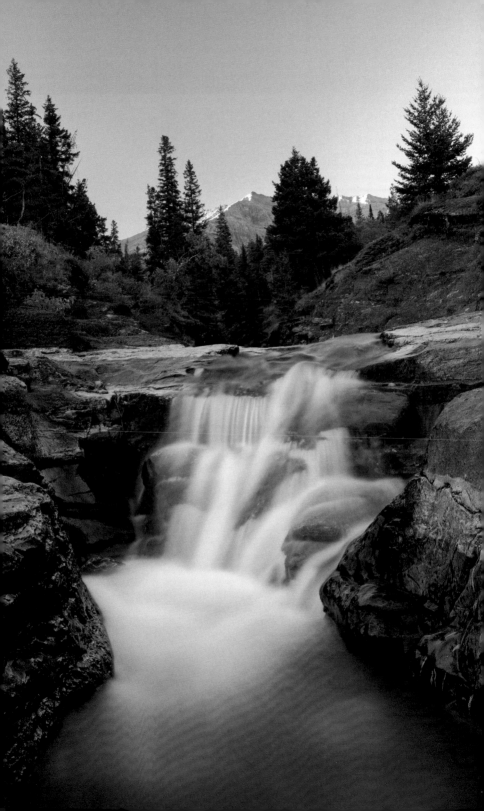

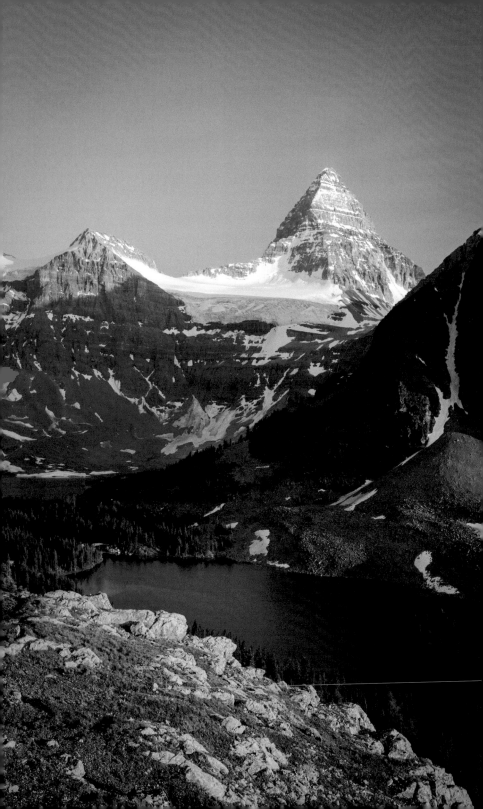

Nicknamed the "Matterhorn of the Rockies" for its resemblance to the iconic peak in the Alps, Mt. Assiniboine (3618 metres) is the highest peak in the southern Canadian Rockies.

The Three Sisters, near Canmore, are known
individually as Faith (Big Sister), Hope
(Middle Sister) and Charity (Little Sister).

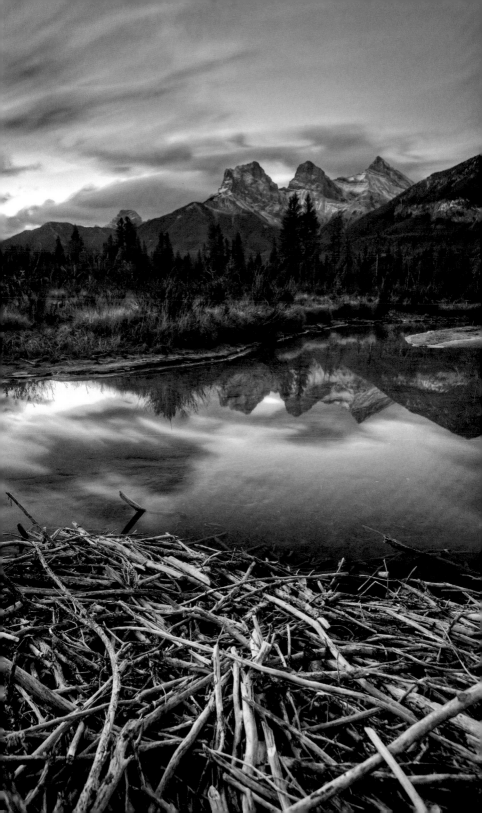

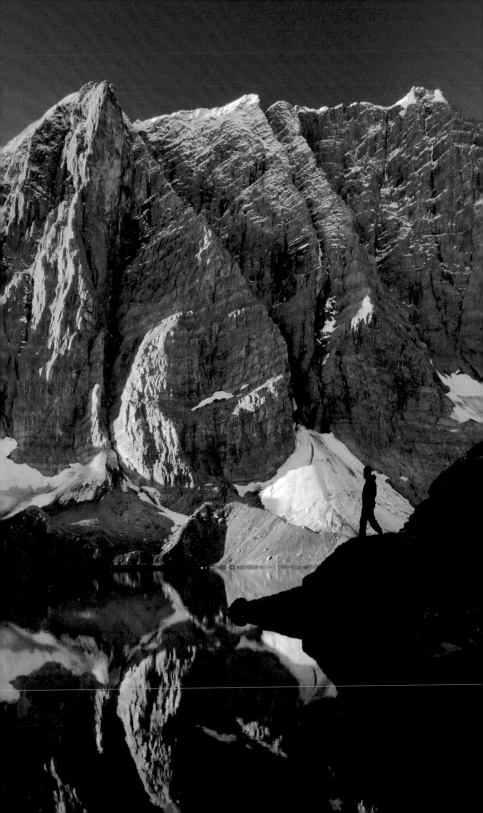

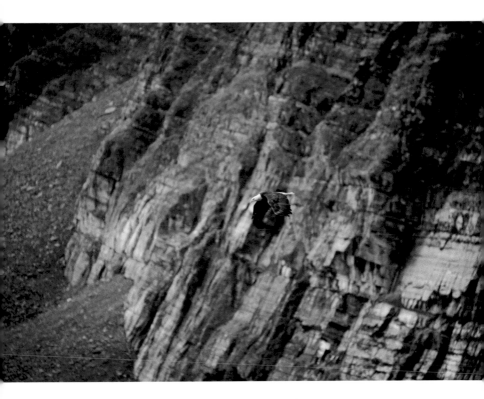

ABOVE *An eagle soars amidst the rocky
peaks at Taylor Lake, Banff National Park.*

OPPOSITE *A classic of Kootenay National
Park, the hike to Floe Lake (pictured here)
can be done as a longer day trip, or as part
of a multi-day backpacking excursion on
the Rockwall Trail.*

BELOW Two mule deer peek through the forest amidst the changing colours of fall.

OPPOSITE Lake Louise is a popular location for sightseeing year-round; in summer, its open waters show a dramatic shade of indigo blue.

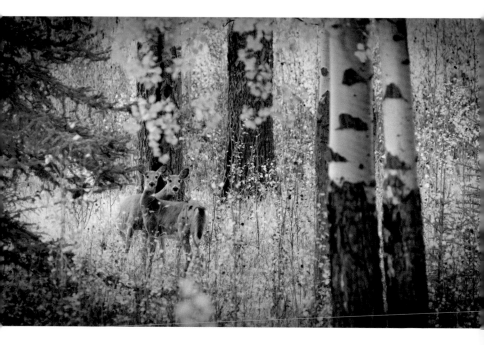

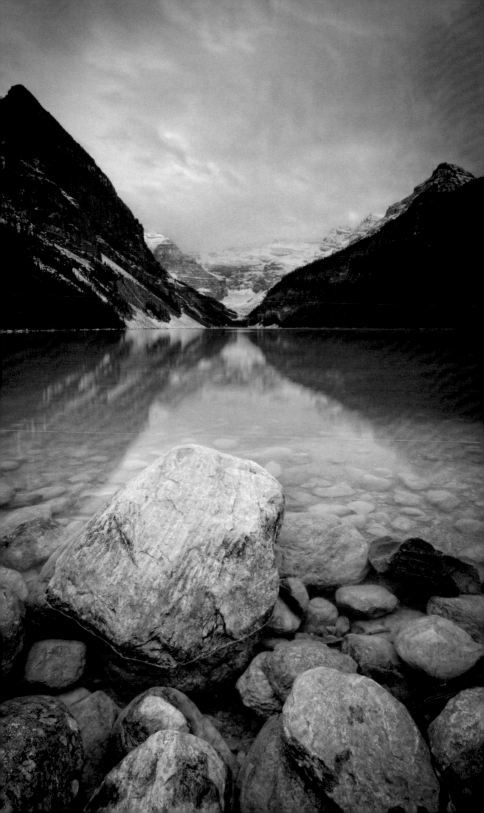

Viewed here from the sky, the Fairmont Chateau Lake Louise and surrounding properties can be seen at their enviable lakeside locations.

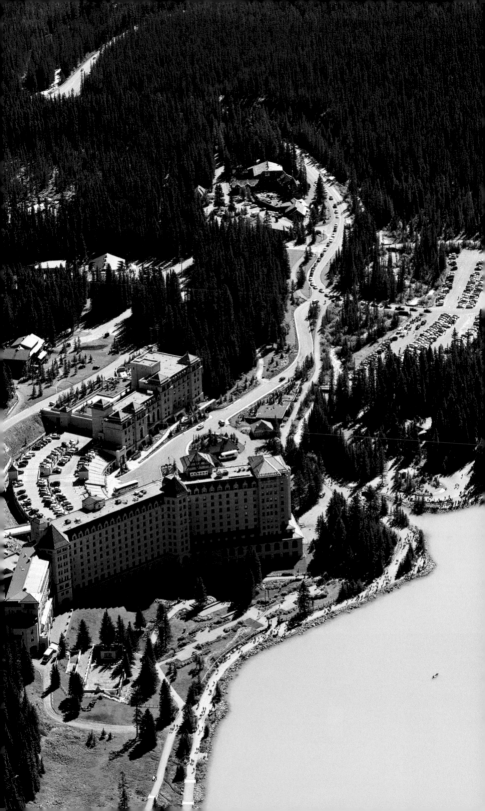

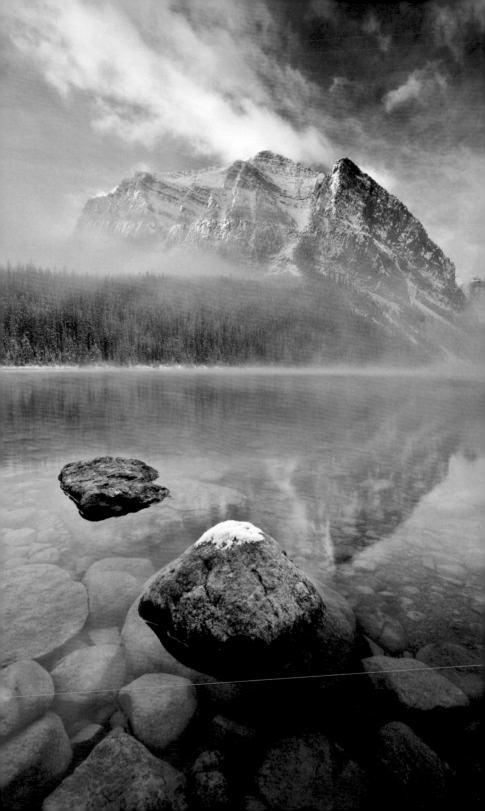

OPPOSITE *Winter sets in at Lake Louise. When the lake freezes it creates quite possibly the most scenic skating rink in the world.*

BELOW *At 3544 metres high, Mt. Temple is a note-worthy peak in the Lake Louise region, easily recognized by its triangular, glaciated summit.*

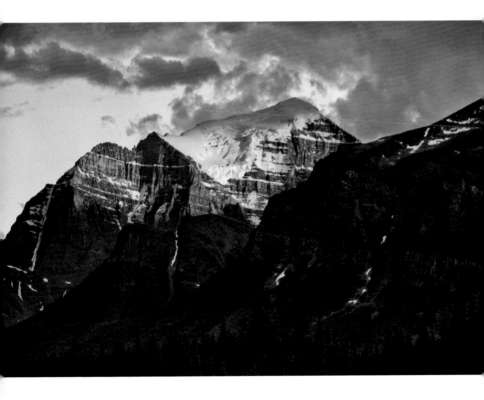

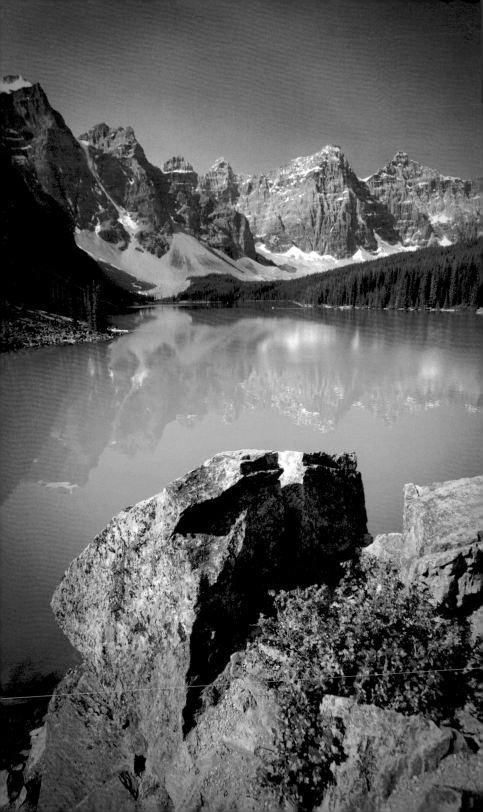

The famous skyline of Moraine Lake is punctuated by the Ten Peaks. This view is also known as the Twenty Dollar View, as it once appeared on the back of the $20 Canadian banknote.

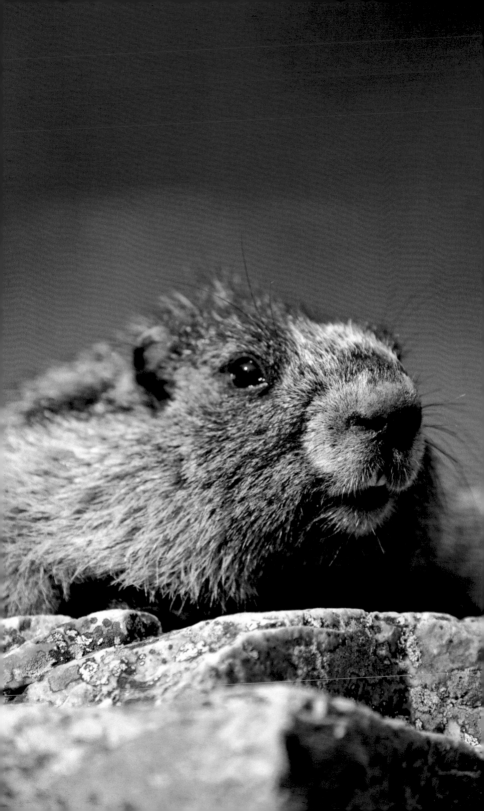

A common resident of alpine regions,
the hoary marmot is often heard
before it is seen, thanks to its distinctly
long and high-pitched whistles.

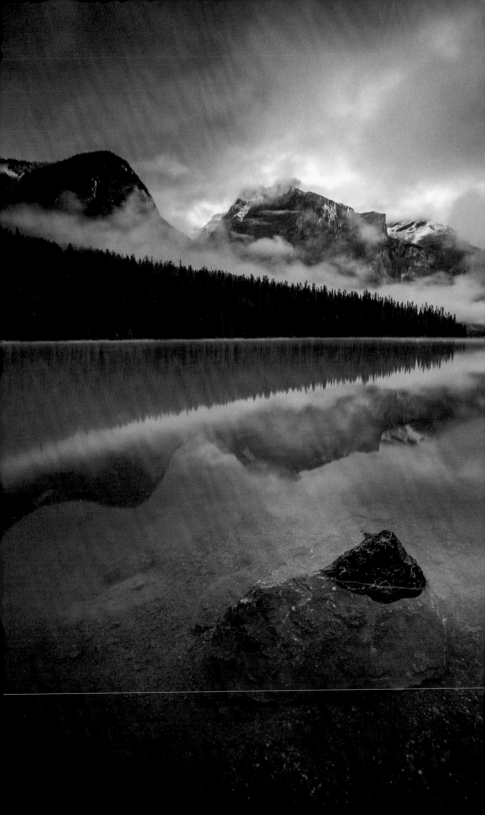

The first non-Native to encounter Emerald
Lake stumbled upon it by accident. In
1882, Tom Wilson was chasing an escaped
team of horses when he came across
the lake. He chose the name because
of the green-blue hue of the water.

At Yoho's famous Natural Bridge the Kicking Horse River meets an outcropping of limestone, and over the years the water has worn it away by force. Now the water pours through a crack in the rocks and a "bridge" remains over top.

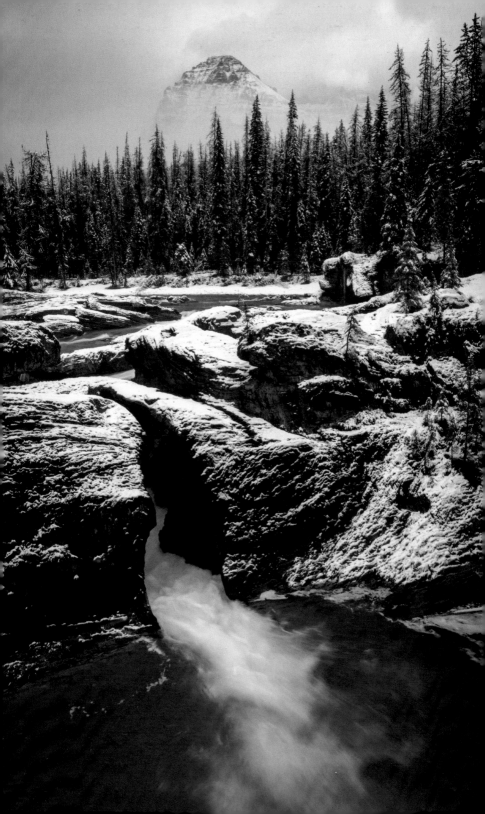

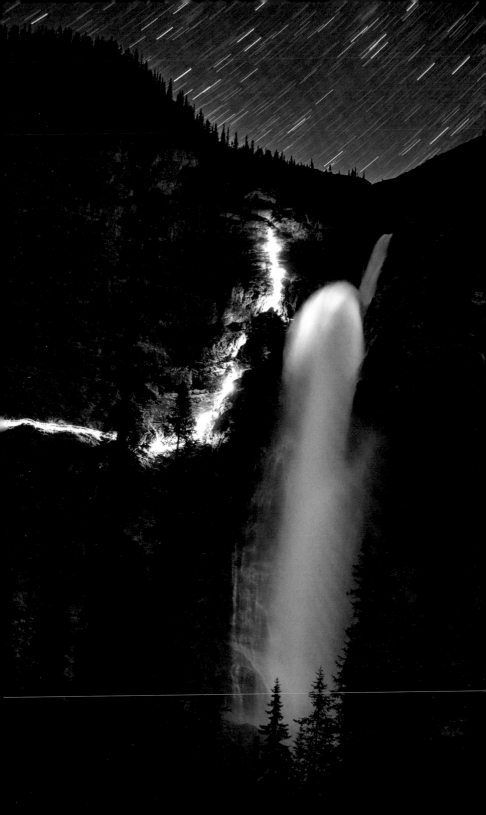

Takakkaw Falls is one of the higher waterfalls in the Canadian Rockies, at 302 metres. Roughly translated, the name means "it is magnificent" in Cree. Here, climbers do a nighttime ascent of the rock wall to the left of the falls.

Lake O'Hara in Yoho National Park is accessible only by bus or a 12-kilometre hike or ski in. The secluded region boasts one of the best hiking trail networks in the Canadian Rockies.

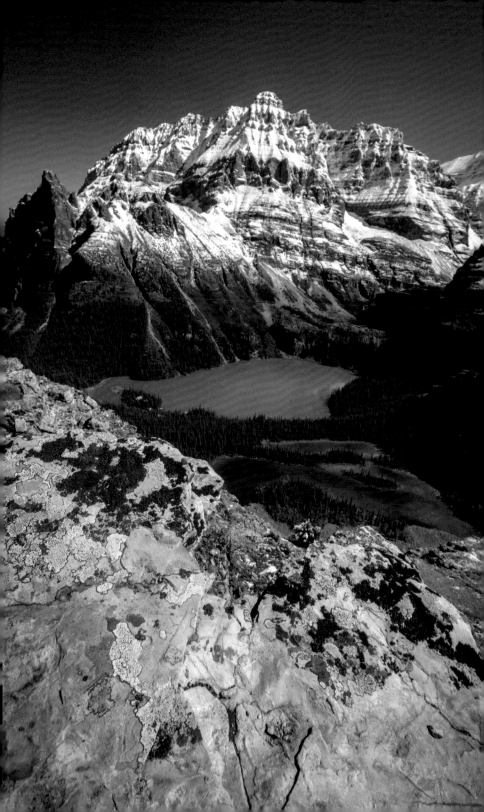

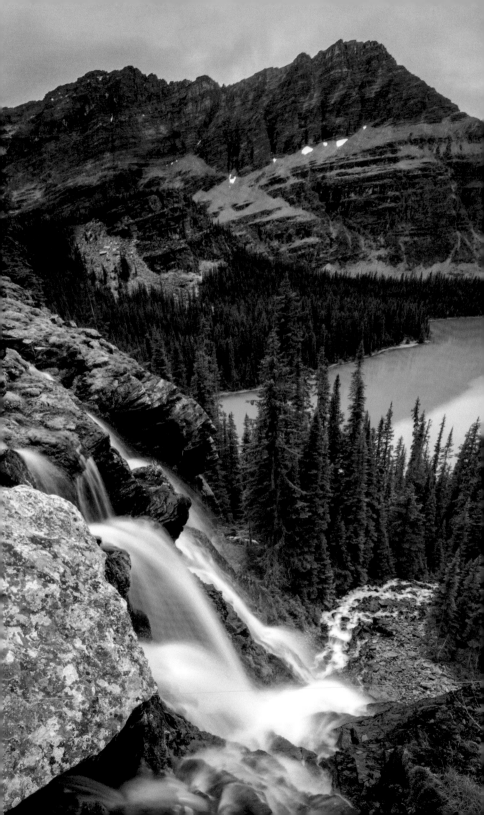

The Seven Veils
Falls cascade down
towards Lake
O'Hara in Yoho
National Park.

A shrubby cinque-foil grows in this subalpine region of Lake Oesa, Yoho National Park.

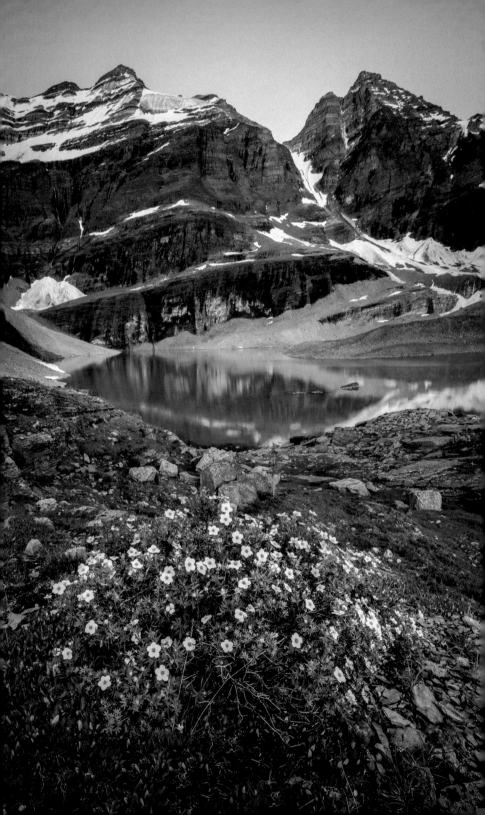

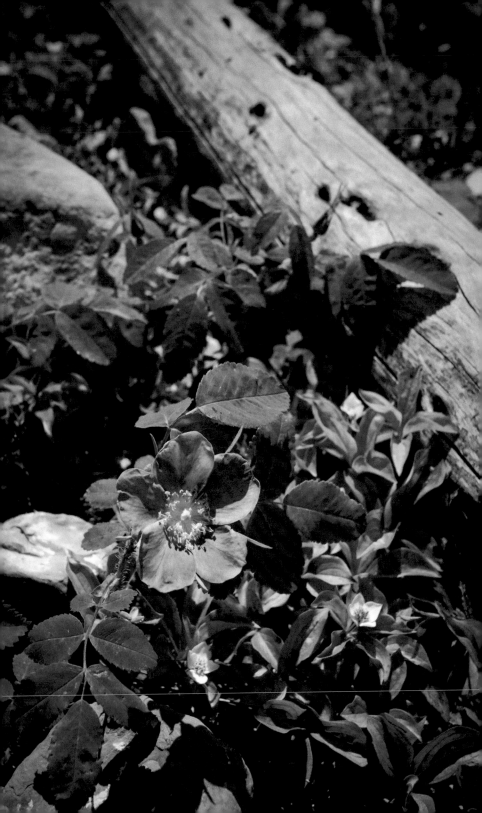

Found throughout the Canadian Rockies, the prickly rose – known commonly as the wild rose – is the floral emblem of the Province of Alberta.

*The Crowfoot
Glacier clings to
the northeastern
flanks of the peak
that bears its name.*

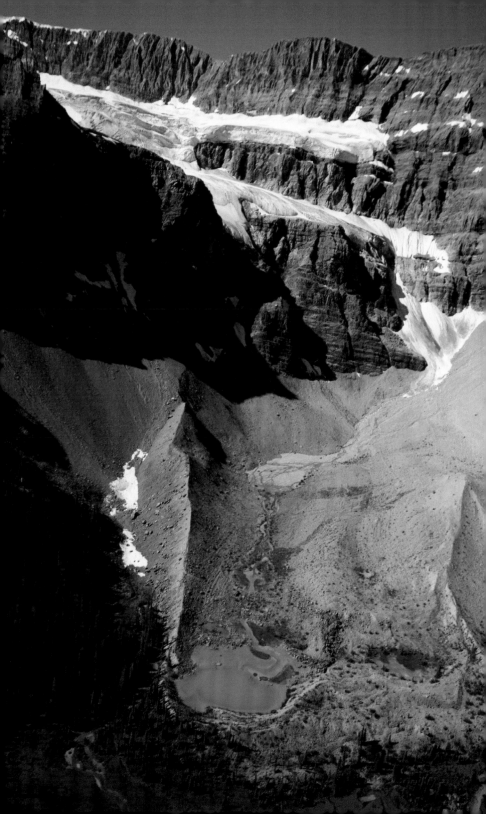

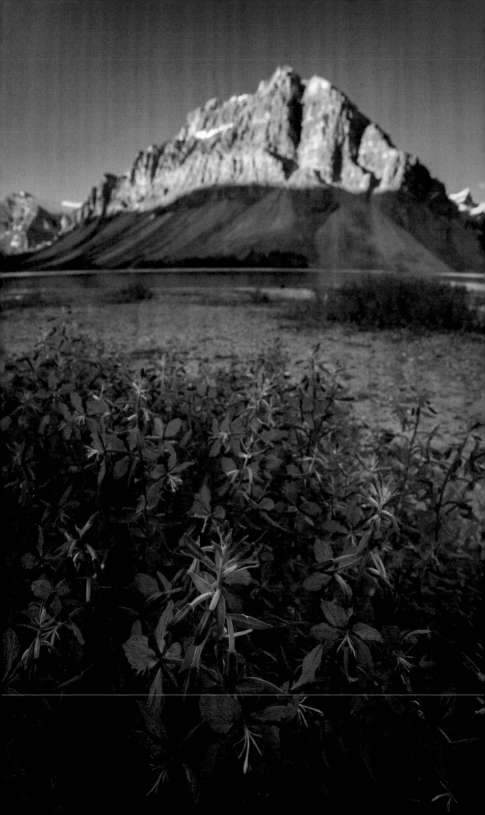

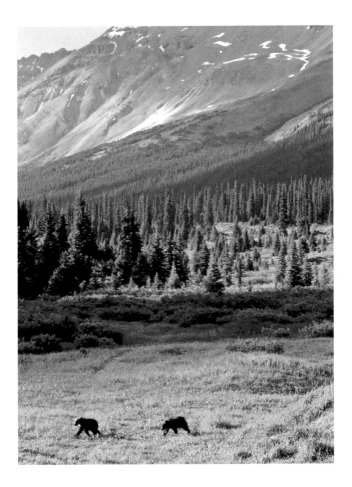

ABOVE *Grizzly cubs play in an open meadow near Bow Lake, Banff National Park.*

OPPOSITE *Crowfoot Mountain stands majestically over Bow Lake, the third-largest lake in Banff National Park. It is here that the Bow Glacier melts into Bow Lake – the headwaters of the mighty Bow River.*

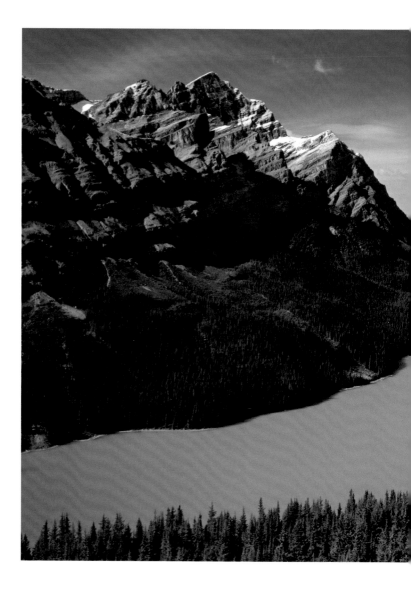

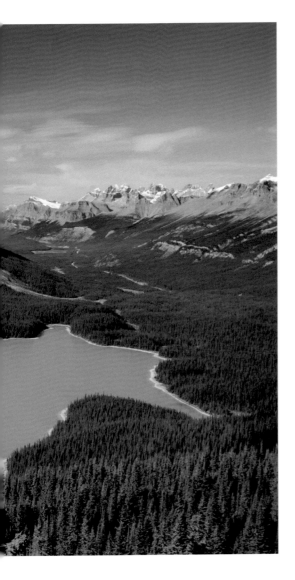

Famous for its opaque blue water, Peyto Lake is a popular stop along the Icefields Parkway. It was named after one of Banff's most iconic historical figures, the outfitter, guide and park warden Ebenezer William "Wild Bill" Peyto.

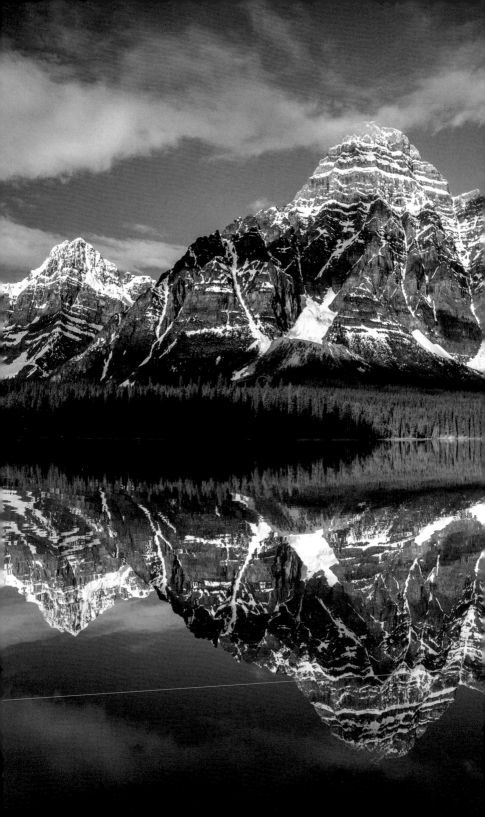

Mt. Chephren is reflected in glass-like water
at Waterfowl Lake, Banff National Park.

A quick walk down from the highway at this roadside stop leads to Mistaya Canyon, where the powerful Mistaya River plunges through steep, smoothed walls en route to joining the North Saskatchewan River.

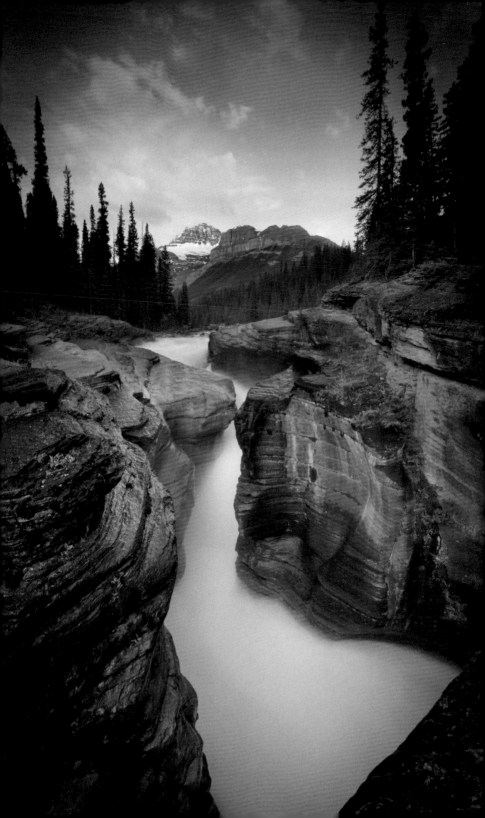

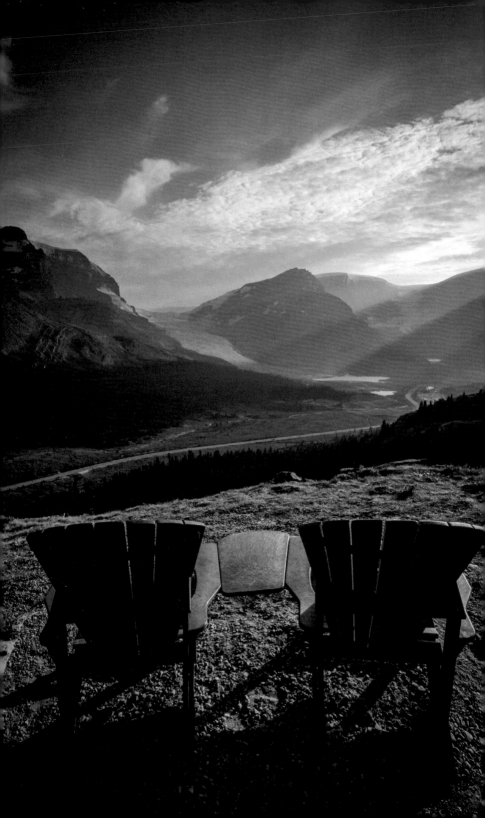

At Wilcox Pass, Parks Canada's famous
red chairs give you a chance to pause
and appreciate the glorious view of the
Athabasca Glacier, Jasper National Park.

This image of the Athabasca Glacier shows the Ice Explorer bus tours about halfway up the glacier, demonstrating the scale and magnitude of the ice.

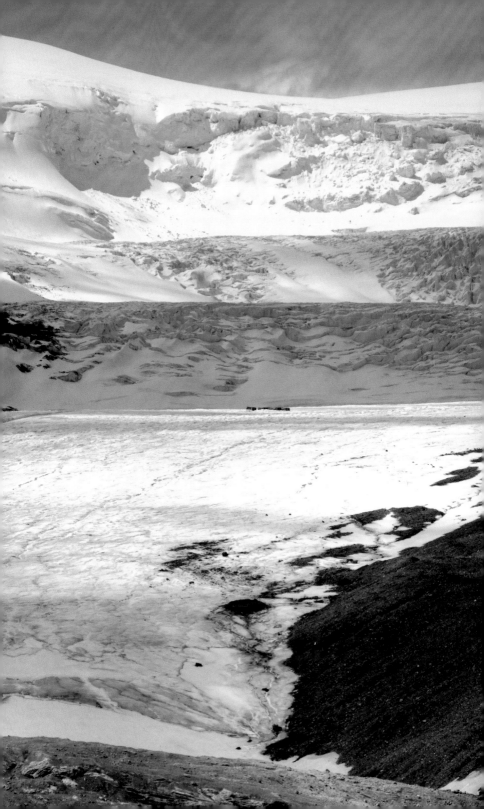

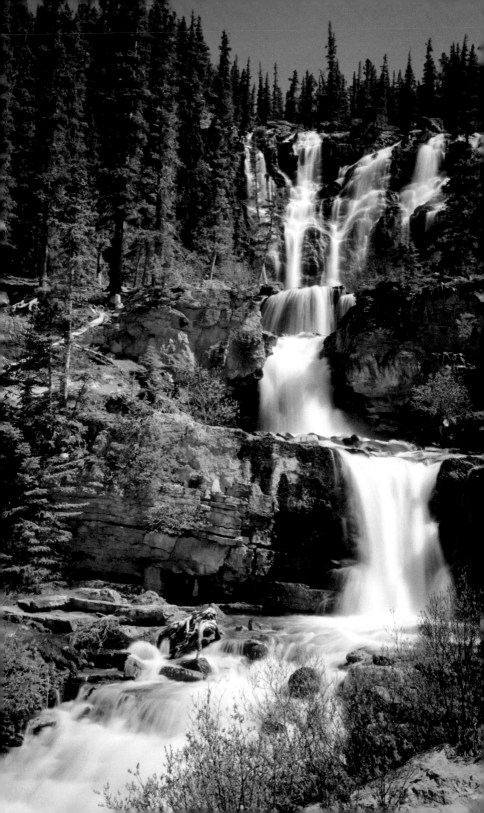

If you blink, you might miss it: the multi-tiered cascades of Tangle Falls fall right along the roadside of the Icefields Parkway.

A gorgeous sight by day or night, Sunwapta Falls is an easily accessible stop in Jasper National Park. Sunwapta means "turbulent waters" in the Stoney language.

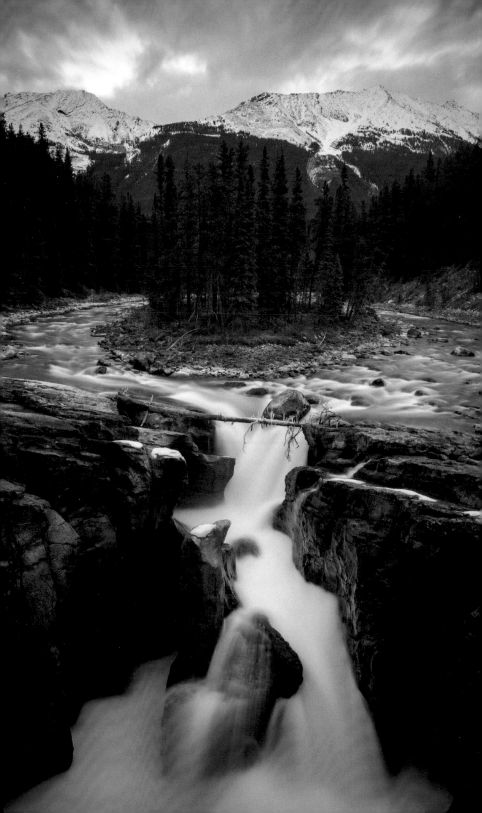

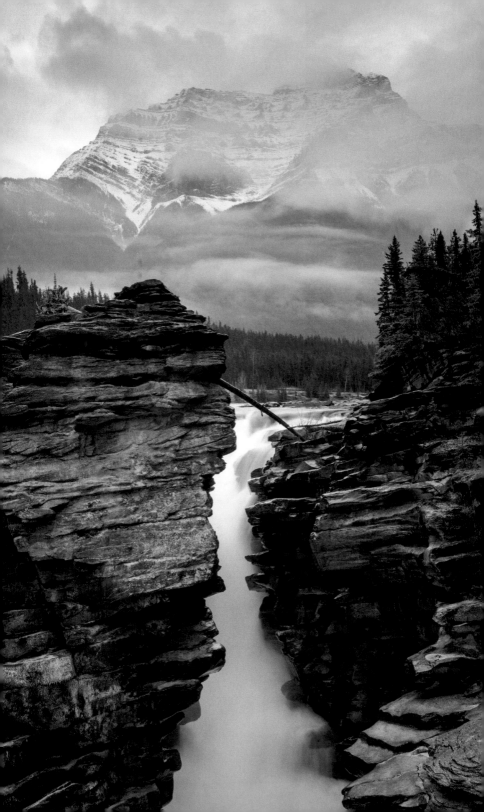

*Athabasca Falls
is known more for
power than height:
the water falls over
tough quartzite
and then carves its
way through the
softer limestone of
the gorge below.*

BELOW *One of
Jasper National
Park's most
iconic peaks, the
illustrious Mt.
Edith Cavell rises
to an elevation
of 3363 metres.*

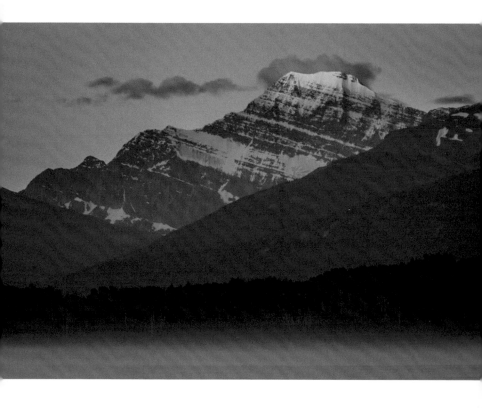

*The bright green
hues of the aurora
borealis light up
the shallow water
of Medicine Lake.*

*Measuring over 50 metres in depth, Maligne
Canyon features a series of walkways
and bridges suspended over the abyss.*

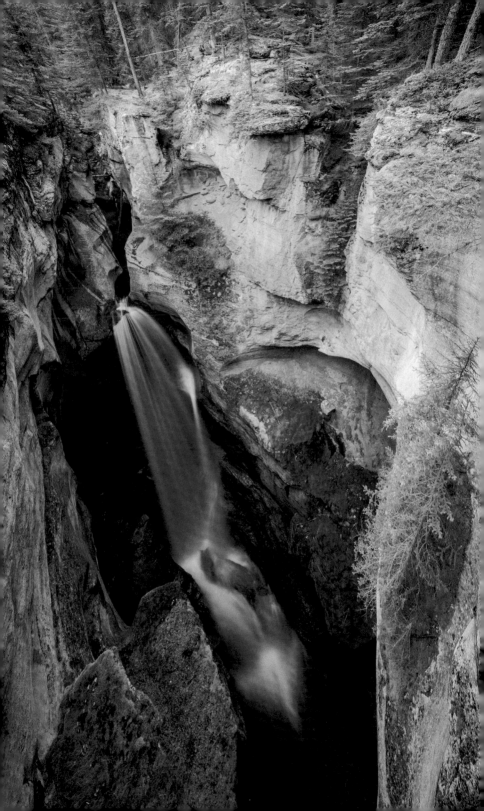

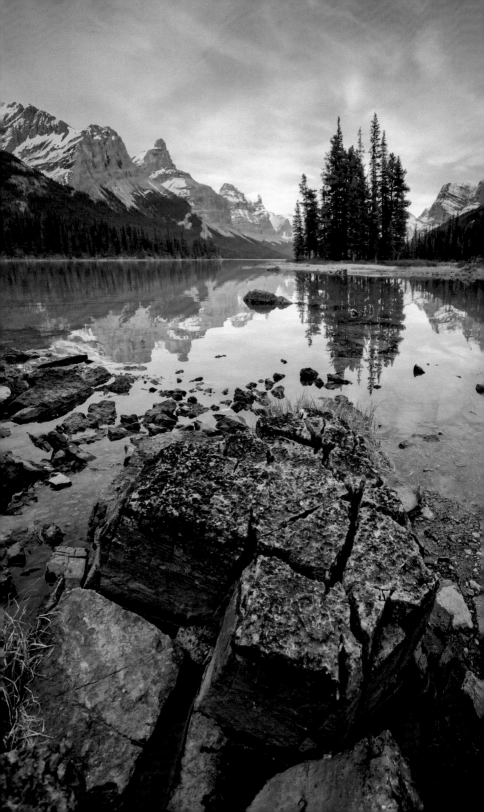

One of the most famous views in the Canadian Rockies is that of Spirit Island and the dramatic scenery of Maligne Lake, Jasper National Park.

Reaching a lofty height of 3954 metres, Mt. Robson is the highest peak in the Canadian Rockies. Known to First Nations as Yuh-hai-has-kun ("the mountain of the spiral road"), the peak is often shrouded in cloud, earning it the nickname Cloud Cap Mountain.

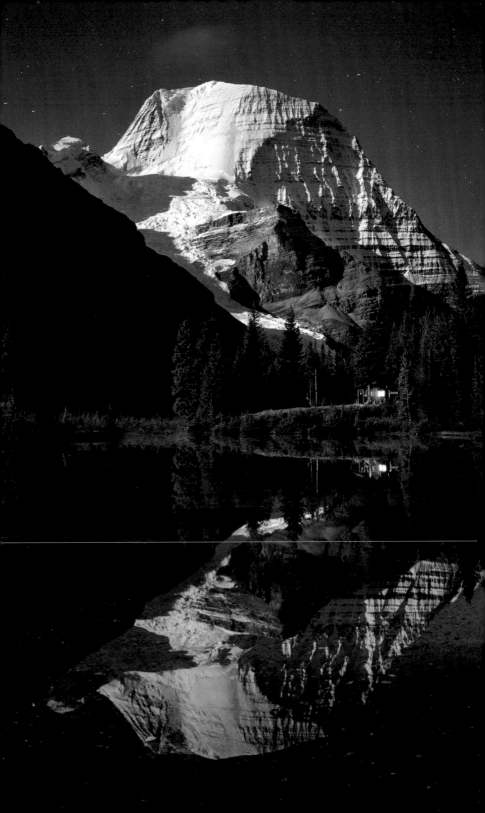

Select Sources

The author wishes to acknowledge the following sources of information for this book:

Peakfinder.com

Wildflowers of the Canadian Rockies, by George W. Scotter and Hälle Flygare

Handbook of the Canadian Rockies, by Ben Gadd

Central Rockies Placenames, by Mike Potter

Banff and Lake Louise History Explorer, by Ernie Lakusta

The Canadian Rockies Trail Guide, by Brian Patton and Bart Robinson

COVER *Lake Louise and Fairview Mountain, Banff National Park.*

PAGE 2 *The sky bursts with colour as the sun rises over Vermilion Lakes, Banff National Park.*

Copyright © 2017 by Paul Zizka (photographs) and Meghan J. Ward (text)
First Edition, reprinted 2018

RMB | Rocky Mountain Books Ltd.
rmbooks.com
@rmbooks
facebook.com/rmbooks

Cataloguing data available from Library and Archives Canada
ISBN 978-1-77160-210-5 (softcover)

Printed and bound in Canada by Friesens

Distributed in Canada by Heritage Group Distribution and in the U.S. by Publishers Group West

For information on purchasing bulk quantities of this book, or to obtain media excerpts or invite the author to speak at an event, please visit rmbooks.com and select the "Contact Us" tab.

RMB | Rocky Mountain Books is dedicated to the environment and committed to reducing the destruction of old-growth forests. Our books are produced with respect for the future and consideration for the past.

We acknowledge the financial support of the Government of Canada through the Canada Book Fund and the Canada Council for the Arts, and of the province of British Columbia through the British Columbia Arts Council and the Book Publishing Tax Credit.